PROPERTY OF: